MASTERS OF PHOTOGRAPHY

JACQUES-HENRI LARTIGUE

Text by Brian Coe

Macdonald

First published in Great Britain in 1984
by Macdonald & Co (Publishers) Ltd
London & Sydney

A member of BPCC plc

British Library Cataloguing in Publication Data
Coe, Brian, *1930-*
Jacques-Henri Lartigue.—(Masters of
photography)
1. Lartigue, J. H.
I. Title II. Series
770'.92'4 TR140. L32

ISBN 0-356-10509-1

Filmset by
Text Filmsetters Ltd

Printed and bound in England by
The Alden Press
Oxford

Macdonald & Co (Publishers) Ltd
Maxwell House
74 Worship Street
London EC2A 2EN

JACQUES-HENRI LARTIGUE

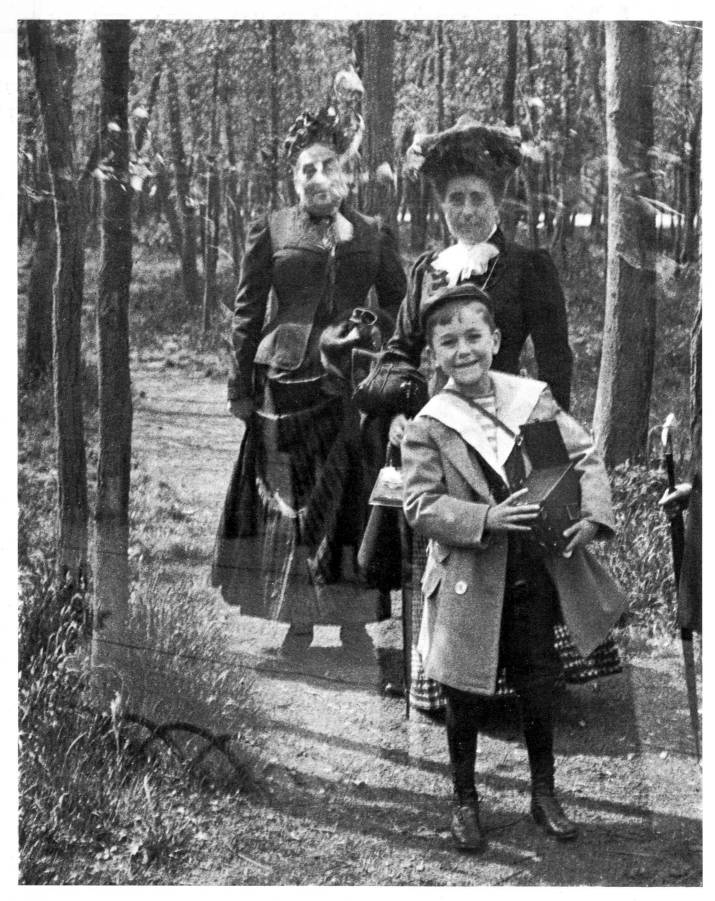

Jacques-Henri Lartigue, 1903

Jacques-Henri Lartigue was born on 13 June 1894 in Courbevoie, the younger son of a well-to-do French businessman with a home in Paris and a summer residence in the Auvergne. Jacques, who was a slight, intelligent and sensitive child, and his elder brother Maurice, nicknamed 'Zissou', were lucky enough to be born to parents who were able to provide the material means and intellectual encouragement to satisfy his curiosity. Lartigue's father was an amateur photographer, and as an infant Jacques was fascinated by the miracle by which a moment of time could be preserved on a photographic plate. In 1901 the six-year-old Jacques was, to his great delight, given a camera. Over eighty years later he is still photographing and is still, in his own words, 'an incorrigible little boy'. Lartigue has chronicled his life and times in writings, paintings and above all in photographs which capture perfectly an era and a way of life that has gone forever. His early photographs caught the spirit of an epoch before the world was plunged into war, when elegant, fashionable women took the air in the Bois de Boulogne and adventurous young men took to the air in primitive flying machines, and when the motor-car was still a novelty and a plaything for the rich. Lartigue was and remains an amateur photographer in the most literal sense. He loves to photograph those things which amuse and amaze him, recording and preserving happy times, rarely capturing sad or unpleasant experiences. In this he joins the millions who, since the end of the last century, have made personal records with the camera. But what distinguishes Lartigue from almost all other photographers is his remarkable ability to capture the precise moment when every element in a scene is perfectly composed.

In order to appreciate Lartigue's photographic genius we should first consider to what stage photography had progressed at the turn of the century. At that time photography had not been a popular hobby for long. Although the first practical photographic processes had been introduced as early as 1839, for the first thirty years it had involved the use of messy and sometimes dangerous chemicals and cumbersome equipment. The photographer had to prepare his own light-sensitive materials and, in the period of so-called wet-plate photography – from the 1850s to the late 1870s – this had to be done on the spot, which meant that a portable darkroom was needed which could be transported from place to place when photographing on location. Exposure times were relatively long, running into many seconds or even minutes, and for this reason the camera had to be placed on a tripod; photographs of moving subjects were out of the question in all but very special circumstances. Because there was no convenient method of enlarging negatives, glass plates of the same size as the final print were required, adding to what the photographer had to carry with him.

All of this changed, however, in the 1870s with the introduction of a new gelatine dry-plate process. A glass plate was coated with an emulsion of light-sensitive silver salts in a gelatine solution. When dried the plates retained their light-sensitive properties for long periods and this made possible the commercial manufacture of dry-plates. The new plates were also much more sensitive to light than wet-plates and therefore exposure times were reduced from minutes or seconds to fractions of seconds. By the end of the century it was possible, using the fastest plates with a good lens and good light, to make exposures as short as 1/1000th of a second. Cameras no longer needed to be fixed to a tripod, and many types of hand cameras with built-in shutters became widely available.

Another important innovation that contributed to the popularizing of photography was introduced by George Eastman, manufacturer of the new dry-plates. Searching for ways to simplify photography, in 1888 Eastman produced the first roll-film camera, the Kodak. One roll-film held one hundred exposures, and Eastman provided a developing and printing service for the exposed film as well. His slogan, 'You press the button, we do the rest', effectively summed up his philosophy. The revolutionary impact of Eastman's services became apparent when we realize that by separating the taking of pictures from the processing of film it became possible for people without any technical knowledge or access to a darkroom to make and enjoy photographs.

During the 1890s various improvements were made by Eastman and others, and in 1900 the first Brownie camera, a simple box camera for roll-films costing only one dollar, was sold. It and its successors brought photography to the people. Jacques-Henri Lartigue was fortunate to have been born when technical improvements in photography for the first time had made the snapshot possible.

Jacques later recalled the first camera he received from his father:

It is made of polished wood, with a lens extension of green cloth in accordion folds. It has a big case with all the accessories. And a tripod stand ... 'taller' than I am! A holder for big greenish-yellow plates, wrapped in beautiful black paper... I am so happy with my camera ... it's fantastic!... I have to climb on a stool to be able to use mine. Somebody drapes the cloth over my head ... I focus ... I pull the frosted glass out and push a holder with a brand new plate... in its place.... remove the black cork covering the lens, count, like Papa: One ... two ... three ... and put the cork back on.

The young Lartigue photographed his parents, his home and even himself, running to stand in front of the camera after taking off the lens cap, a procedure which gave him a transparent, ghostly look in the photographs. These posed time-exposures did not satisfy him, however, and in 1903, at the tender age of eight, he was given a box-type hand plate camera with a shutter speed of 1/50th of a second. At last he could take snapshots, even if the camera was still not very versatile. In the following year he received his first advanced camera: the Block Notes by Gaumont. In its day this was considered a miniature camera using plates $1\frac{1}{2} \times 2\frac{1}{2}$ inches in size and an adjustable shutter with speeds up to 1/100th of a second. Two years later he acquired an improved Block Notes with shutter speeds to 1/300th of a second and a push-pull plate changing magazine that permitted twelve plates to be exposed in quick succession. The Block Notes was Lartigue's favourite camera and was used for most of his photographs.

Between 1904 and 1910 Lartigue also used his father's Gaumont Spido camera, which took two stereoscopic photographs (or a single panoramic picture) on a $2\frac{1}{2} \times 5$ inch plate. (In stereoscopic photography a pair of photographs was taken by two lenses separated by approximately the distance between the human eyes. When the two pictures were viewed in a stereoscope, an optical gadget that permitted each eye to see only the picture appropriate to it, they blended to give the illusion of a picture in three dimensions.) Lartigue's interest in stereoscopic photography continued with his acquisition in 1912 of a Nettel Stereo-Deckrullo $2\frac{1}{2} \times 5$-inch stereo-panoramic camera. Having a focal plane shutter that worked to the very high speed of 1/1200th of a second, this very advanced camera allowed him to make the action photographs of which he was so fond in three dimensions as well.

Most of Lartigue's cameras were capable of taking fast-action pictures and most of his early photography was done with plate cameras, although he also used roll-film cameras for holiday and landscape pictures. In later years he used various roll-film cameras, and more recently 35mm cameras. From 1912 he also used a Pathe Professional 35mm cine-camera to make films of action subjects, some of which were used commercially.

Almost all of Lartigue's earlier photographs were made on rapid plates (at the time most manufacturers sold plates in three grades: ordinary, medium and rapid) which had a sensitivity approximately equal to 50 ASA. Therefore the fastest black-and-white plates available to Lartigue were no faster than the slowest colour films of today. In about 1911 he learned of Ilford's Extra-Rapid plates, which enabled him to use very fast shutter speeds of up to 1/1000th of a second for his action pictures. From 1912 he also began to experiment with colour photography, using Lumière Autochrome colour plates. The lack of colour in his photographs had bothered him:

I think that monochrome photography is a form of interpreting reality, but as Nature is full of colour, colour photography should be the norm.

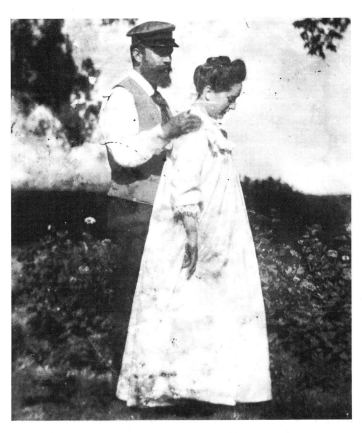

Papa and Mama, 1902

The Autochrome colour plates, introduced by the Lumière brothers in 1907, worked on the additive principle of colour photography; that is, they incorporated a random mosaic of tiny red, green and blue colour filters, which gave the picture something of a *pointilliste* effect. While the colour quality of the plates could be very good, Lartigue found they had drawbacks. One very important problem to him was that the plates were extremely insensitive and required exposures of several seconds in the brightest light, which meant that his favourite action subjects were out of the question. Another problem was the progressive and unpredictable changes in colour which occurred after the plates were processed. Nonetheless, Lartigue used Autochrome plates and his stereoscopic Nettel camera well into the 1920s to make many pictures of great charm, but gave up colour after 1927 until about 1950, when he began again with modern materials.

Lartigue was never obsessed with gadgets: he gauged exposure by experience rather than by meters; he guessed distance settings by training himself to estimate and then checking the distance of objects around him in his home. He was rarely wrong. Much photographic equipment today is automatic in operation, and of this Lartigue has said:

> I continue to prefer cameras which are not completely automatic, since these prevent me from catching what I want in the subject. To sum up, I believe that while technique is a useful base [relatively easy to understand] it must remain subsidiary to the photographer who, like the painter, or even the writer, must have above all the eyes to see, controlled reflexes and a heart to love, understand, predict and try to catch the things of life as they pass.

For sixty years Lartigue documented his world solely as a personal and private record. From the beginning he put all of his photographs into albums and each picture was titled and dated. Lartigue also kept detailed diaries, recording each day's activities from waking to sleeping – the weather, games, meals and excursions. When he returned from photographic excursions he made little sketches of each of the photographs he had taken that day. Remarkably, these drawings capture exactly the actions and poses of his subjects, showing that Lartigue's mind's eye, like his camera, had preserved the image. After developing the plates he would cross out any of the sketches for which the photographs had not turned out. Together the diaries and photographs present a unique and detailed picture of one man and his world. He made the records, he has said, because of 'a wish to live on a little – at least to try to'.

It is apparent that from the start the young photographer was obsessed with capturing the brief moment: 'I enjoy photographing things that happen too quickly to see but which the photograph can capture – that's really tremendous'. Very few of Lartigue's photographs were posed; they caught life on the wing, for in his own words, '. . . it was a sort of obsession to catch the passing moment.'

Although by the early 1900s the technology of photography had advanced to a point where this was possible, it was by no means an easy matter.

There were two problems. First, to stop the action of a rapidly moving subject requires a fast shutter speed – the faster the movement to be captured, the faster the shutter speed needs to be. While 1/50th of a second might freeze the movements of a woman strolling in the Bois de Boulogne, 1/500th of a second, or even less, might be needed to catch cousin Bichonnade as she leapt down a flight of steps. Such very brief exposures were only possible if everything was perfect: good light, the fastest plates, a good lens with a wide aperture and careful processing. Most of Lartigue's contemporaries were put off by such complications and stuck to less demanding subjects. And, even if the technical difficulties were mastered, there was a second even bigger problem. To capture a fast-moving subject at precisely the right moment is not easy; if the shutter release is pushed exactly at the moment that the image is seen in the viewfinder, it is too late. The physiological and mechanical delay between seeing and exposing ensures that the critical point will be missed. Lartigue summed up the problem thus:

There is an absolutely critical moment – but it's only 1/100th of a second. If you've played tennis you'll know that. You foresee the moment – you have a presentiment of that fraction of a second which is coming and 'click' – it's got to happen before you have even time to think.

This ability to anticipate that vital fraction of a second is Lartigue's special gift and few photographers have it to anything like the same extent. Today motor-driven cameras permit several exposures per second, increasing the odds that one photograph in a sequence may be right. Lartigue, with his one plate and one chance, had to get it right the first, and only, time.

Yet Lartigue's special skill is not just a matter of catching the subject at the right moment. Although more subtle, of equal importance is the subject's relationship with its surroundings, with other subjects and with the border of the photograph – in other words, composition. Lartigue's action photographs frequently show a visual balance and har-mony between the components of the scene which would be remarkable enough in a carefully posed shot, but when combined with his ability to capture the precise moment of action borders on the mira-culous. The choice of distance, angle and moment of exposure all had to be exactly right. Many press photographers have the ability to catch the key moment; few have the ability, or opportunity, to create the perfect composition as well. This power-ful combination of exact timing and composition is characteristic of Lartigue and distinguishes him from his contemporaries.

Lartigue's early photographs fall into three main groups: first, his carefully observed and captured records of beautiful, fashionable women strolling in the Bois de Boulogne or promenading at the sea-side; second, the extraordinary action pictures of his family and friends at play; third, the photo-graphs that illustrate his fascination for new and exciting modes of transport – motor-cars, airplanes and dirigibles. Although his subjects vary widely they have one element in common – action.

In the years of *la belle époque*, before the First World War, every fine day Parisian society fre-quented the tree-lined avenues of the Bois de Boulogne. As Lartigue has related:

The pretty, fashionable women went at midday to the Bois to meet, show off their new dresses – every morning. This greatly entertained me and when I had finished school work I hurried, running, to the Bois, every day at midday. I greatly admired the considerable talent of the dress designers and I was very interested in the latest fashions and new hats because they were beautiful to see.

The teen-aged Lartigue would take up his station on one of the iron chairs which lined the avenues of the Bois, with his favourite Block Notes camera shutter cocked, aperture set and distance adjusted, waiting for an attractive subject: 'As they approached, sitting on my chair I thought, that's amusing, that's beautiful, raised my camera and "click"'. He never asked permission before taking the picture and sometimes the subjects did not realize that they had been photographed. But if he

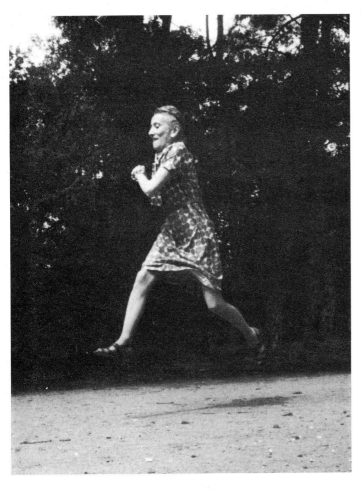

Simone's seventy-fifth birthday, 1968

Late Edwardian fashions were extraordinarily extravagant, especially the women's hats, and Lartigue's photographs have all the detail of a fashion plate but with the added dimension that the clothes are worn by real people in real settings. Many of his photographs of strolling women display his impeccable sense of composition in scenes that incorporate several moving elements. One of his best-known pictures, of a woman in furs and a grand hat walking two little dogs, is typical: the proud carriage of the woman, and the eager, alert stance of the dogs as they walk towards the camera is complemented by a motor-car and a carriage passing in the opposite direction in the background. There are five independently moving objects within the frame of the photograph, and all are in just the right relationship to each other – even the shadows of the woman and the dogs fall in the right place. Another of Lartigue's pictures, taken on the beach at Villerville, shows the same remarkable mastery over a scene with contrary movements. Two women with sunshades walk towards the left of the picture; Lartigue's father walks in the same direction in the foreground. Behind, three men with identical strides walk off to the right. The opposing movements of these two groups meant that there was only a fraction of a second in which everything was compositionally perfect and Lartigue caught it. Most of us would not.

Throughout Lartigue's life attractive women have been a favourite subject. When the high fashion of the pre-war years gave way to the dress of the *garçonnes* in the 1920s, he was there with his camera to catch the girls in their boyish costumes. And with the trousers and cupid's-bow makeup came a new habit – cigarette smoking. Until then this had been, for women in public, virtually unknown and Lartigue was amused by the absurdity of it all. In 1927 he photographed many of the women well known in the theatre of the day, including the Dolly Sisters and Josephine Baker, smoking cigarettes, capturing the frivolity of the period. Lartigue's sense of fun is revealed in many of his pictures from all periods; his great delight was, and still is, to capture things which amused him, and if they also involved beautiful women, so much the better: 'I have always liked to take pictures of

used one of his cameras with a noisy shutter, he sometimes had problems: 'My camera was very noisy; when the women were alone, they usually smiled, but when they were with a gentleman, he was often angry. But when I was very young I said to myself, alright, they're angry and that's a bother but I had the photo. That's what mattered'.

Generally his 'victims' never saw the results. But on one occasion he photographed an attractive woman walking with another woman and a little girl. He recognized her as Regina Badet, a well-known dancer from the Opéra Comique. As he walked away he was approached by the girl's governess and was brought to meet the famous dancer, who 'asked me to bring the photo to her home, but since I was very shy I was scared. She was a famous dancer... and I was a rather small seventeen-year-old, so I got my brother to take them to her!'.

women, fashionable ladies, mannequins, *demi-mondaines*. They all have a style so unlike men. For me they are like cakes in a bakery — delicious to look at even if one is not very hungry, smelling good even if one is not tempted.'

Lartigue's obsession with capturing the fleeting moment is nowhere better seen than in his photographs of his family and friends enjoying themselves. Born into a family sufficiently well off to have abundant leisure and the means to enjoy it, the young Lartigue was also fortunate in that those around him, both young and old, were fond of fun. Highjinks seemed to have been the order of the day on those summer holidays at the family château at Rouzat. Much energy was expended and no little risk taken on the business of bob-carting; two- or four-wheeled sledges were designed and constructed and driven at speed downhill (frequently, on cornering, they turned over or buckled their wheels). Lartigue photographed these moments of drama, catching, as always, that critical moment when clouds of dust or flying limbs made the picture just right. In the 1905 photograph of big cousin Jean Haguet and Louis Ferrand cornering in a four-wheeled bob, for example, the sliding turn has thrown up successive curved clouds of dust which echo the shape of the wheels. This, and the strained attitudes of the crew, give the photograph an extraordinaily dynamic effect which is increased by the oval distortion of the wheels produced by the focal plane shutter of the camera. The construction of such shutters meant that rapidly moving objects were distorted, the effect being most obvious, for example, on wheels, where the round shape becomes an oval. This impression of leaning into the movement gives greater feeling of speed.

Another example of Lartigue's ability to use a fast shutter speed combined with exact timing appears in the photograph of cousin Simone tumbling from a two-wheeler on a downhill path, arms and legs flying. The family's ingenuity was not limited to homemade wheeled vehicles; other inventions caught by Lartigue's camera were a paddlewheel raft powered by a converted bicycle, rubber waders with inflatable floats for walking in water and a variety of flying machines – kites, gliders and even airplanes.

Lartigue sometimes responded to the challenge of capturing movement for its own sake. One of his most remarkable pictures is of cousin Bichonnade caught in mid-flight as she leaps down a flight of steps. A fast shutter speed has frozen all but the quickest movement (her hands) and she remains suspended for all time. Yet the thrust of her left knee and the attitude of her whole body convey her forward and downward movement exactly. In the delightfully captioned 'M. Plitt teaching his dog Tupy to jump over a brook', poor Tupy has just been thrown from the hands of his master across a stream. Launched into flight, Tupy's attitude suggests a certain apprehension! Again, while the movement is frozen by Lartigue's camera, the lines of M. Plitt's body continue through those of the dog to give a dramatically dynamic effect to the photograph. Similar are Zissou's grand leap with an umbrella for parachute from a high wall, Oleo's jump over four chairs, big cousin Jean Haguet's backwards fall into the swimming pool, or André Haguet's fall, waterwings and all, in an attitude of prayer.

In all of these pictures we see beyond the moment caught by Lartigue's camera in our mind's eye. We know what is about to happen: Zissou and Tupy will land; Oleo will – or will not – clear the chairs; the Haguets will fall with a resounding splash. Some action pictures freeze their subjects so well that they convey no sense of movement; not so with those of Lartigue.

Apart from these frolics Lartigue recorded family and friends at sport. Noteworthy are the photographs of the young Suzanne Lenglen, who at fourteen became the French ladies' tennis champion and who later was to lead the world. Suzanne's commitment to the game is conveyed perfectly. All of her energy and drive is channelled up and into the outstretched racquet and she remains suspended above, but separate from, her shadow, which falls towards us. It is a picture full of life and energy and in marked contrast to another tennis picture of opera singer Arlette Dorgere. Here the only hint of action is in the blur of the ball, just struck and in flight, and the suggestion of tension in Mlle Dorgere's tense, lip-biting expression.

Lartigue also tackled winter sports, a subject

made more difficult because of the poor winter light. Cousin Simone, with her partner Charles Sabouret, won a prize in the French ice skating championships at St Moritz in 1913 and Lartigue caught the pair perfectly as Charles lifts Simone in a turn. Compositionally, her outstretched left leg and his right form converging lines which carry the eye to the apex of the triangle formed by their two bodies. As with so many of Lartigue's photographs it provides all the clues through which we can see the whole of the action, of which the picture represents only a part. In contrast, another picture shows three skaters arm-in-arm, sedately moving towards us, leaning into a turn. They convey an attractive sense of leisurely, unenergetic activity. In quite a different vein, early French film comedian Max Linder is caught clowning on skis, trousers about his ankles and apparently about to fall flat on his face, whether for the film cameras or just for fun we cannot tell.

Lartigue's world was one in which celebrities were commonplace. One entertaining photograph depicts actress Gaby Deslys, in fashionable bathing suit and large-bowed bathing cap, walking at the edge of the water while bathing-suited movie cameramen, the sea half-way up their tripod legs, busily crank their machines. In another Lartigue has caught actress Yvonne Printemps up to her neck in the sea, laughing at the camera which he has held just above water level to produce a lively and informal portrait. Such pictures well convey Lartigue's aim to record 'everything which pleases me, everything I am keen on, which delights or amazes me. The rest I let pass'.

The new technology of transport was of special interest to Lartigue. Soon after he was born the internal combustion engine had become commercially viable and the young Lartigue grew up surrounded by cars – his father, a prosperous financier, could afford what was at the time a considerable luxury. Many of his early pictures feature the family car, or its misfortunes, as in the photograph of Yves the chauffeur and Zissou repairing a puncture while the family look on. Other pictures were taken during drives – encountering a herd of sheep or taking part in a race. But, as we might expect, the most dramatic pictures are of cars in motion.

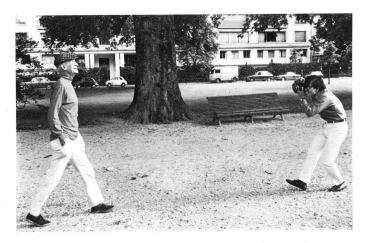

Posing for Hiro, 1970

Lartigue and his family visited the motor-racing circuit in the Auvergne in 1905 and from that time onwards sports and racing cars became his passion. One of his best-known pictures was taken at the Automobile Club de France Grand Prix race at Dieppe in 1912 in which Lartigue panned his camera to follow a Delage racing car rushing past, releasing his shutter as he did so. The focal plane shutter of his camera produced the effect of oval wheels leaning forwards, and because the camera itself was moving during the shot, the stationary spectators are distorted, leaning in the other direction. The result conveys a sense of speed remarkably effectively. In complete contrast, another motoring picture shows a car with a body like an airplane fuselage overtaking a cyclist. Here again Lartigue panned his camera to follow the action, but because it had a conventional shutter, the wheels are true circles. The strong circular motif of the bicycle and car wheels is repeated in many details – crankwheel, hubs, suspension fittings – producing a satisfying picture which is enhanced by the relationship between the cyclist, whose head is turned to see the passing car, and the driver, hunched in his aircraft-style cockpit, concentrating on the road ahead.

Exciting though motor cars might have been to a lad in the first decade of this century, there was soon to be a new, even more dramatic challenge: flight. Lartigue's brother Zissou, having become bored leaping off walls with umbrellas, built large box-kites, almost big enough to lift a person, and

flew them in the grounds of the family château. Of course younger brother Jacques was always there to record the trials with his camera. The next stage was to build gliders; Zissou with the help of the village carpenter and the entire staff of the château made several biplane gliders which got him a few feet off the ground before they crashed or disintegrated in flight. Many of these pioneering aviation experiments were photographed by Lartigue. One notable picture, taken from a hillside, shows Zissou a few feet in the air, hanging from his biplane while an estate worker hauls on the towrope in the foreground. The physical tensions of the event are beautifully captured: the taut towrope leading out of the picture, the nose-up glider about to stall and crash, and Zissou dangling precariously from his frail craft – but flying nonetheless. In yet another photograph Lartigue caught a monoplane glider leaving a hilltop, right wing down and just grazing the ground while the released towropes twist crazily in the air. The crowd of onlookers watch nervously as the machine appears to head for a certain crash. The angles of the hillside, the distant landscape and the banking plane form a strong composition created, once again, by Lartigue's immaculate sense of timing.

Powered flight, still in its infancy before the First World War, fascinated Lartigue, and he photographed many experimental flights at the airfield at Issy-les-Moulineaux near Paris. Most early flights were brief and usually ended with a crash, rarely involving serious injury since the speed and height of the plane were so low. Lartigue loved to photograph these little accidents which took place almost too quickly for the eye to see, but which the camera could capture. One of a more successful flight shows a biplane passing over a road lined with parked cars and spectators. The frail, skeletal airplane is seen against a dramatic sky as, about fifty feet up, it just passes over the telephone wires. The converging lines of the road lead the eye directly to the aircraft. Taken a moment earlier or later the picture would have failed.

Among photographers Lartigue is a great optimist: 'I have always been happy to take things as I find them. Even now, when everyone says times are bad there are very exciting things. It's an opti-mistic point of view – but when I can fly to New York in six hours, that's a very good thing. All times are happy and all countries are good – that philosophy suits me.' Some have complained that Lartigue's view of the world is too cosy and shows only good times and a privileged group of people. Of course – that is why he took the photographs: 'It's not that I avoid taking tragic subjects. It's just that I don't want to preserve sad moments....'

Remarkably, apart from a few friends to whom he showed his albums, no one knew of Lartigue's collection of well over two hundred thousand photographs until 1963, when a selection of them were shown in a ten-page feature in *Life* magazine. An exhibition followed in the same year at the Museum of Modern Art, New York, and subsequently a large show was held at Photokina, Cologne, in 1966. Exhibitions were later held in London, Marseilles, Hamburg, Montreal and Tokyo, among others. His ninetieth birthday in 1984 was marked by a major exhibition in London.

Perhaps more importantly it is through books and other publications, in which Lartigue's photographs are given an added dimension through the commentaries based on his diaries that we get a more intimate glimpse of the photographer. Unlike the work of so many of the great names in photography, Lartigue's photographs were never published when they were made and therefore we see his photography in retrospect. His more recent work, while still showing all the characteristics of perfect timing, faultless composition and remarkable visual balance, has not yet acquired the patina added by the passage of time. His early photographs provide us with a time-machine through which we can visit times past.

Lartigue's talent for seeing in his mind's eye exactly what he wants in his photographs and his ability to foresee the moment of truth to achieve this make him, in Richard Avedon's words, 'the most deceptively simple and penetrating photographer in the short... embarrassing history of that so-called art'. Lartigue, a gentle and humble man, likes to think of himself as being like a cook who picks fruit to make jam, but who prefers to eat the fruit fresh. His zest for the fresh fruit of life continues unabated; we must be thankful for the quality of his preserves!

FRAMING AND MOUNTING

There are a number of ways to display photographs, depending on your personal taste, the picture itself, your initiative and the amount you wish to spend. The simplest method is to use ready-to-assemble framing kits, which will only take about 10 minutes of your time; but if you want a truly professional look, you might wish to mount or mat your photographs and then have them framed – or do it yourself.

Mounting

Like any kind of print or drawing, a photograph must be secured to a stiff surface before it is framed to keep the picture flat and to keep it from slipping about inside the frame. There are a wide variety of mounting boards available, in many colours and thicknesses, or weights, so it is best to go to an art shop, tell the assistant what you need and look through their stock. Remember, if the photograph is large you will not want the board to be so heavy that when the picture is framed it falls off the wall!

There are three mounting techniques: dry, adhesive and wet. Dry mounting should be left to a professional (most photographic processing firms offer such services) because it requires a special press, but the other two methods can be done easily at home.

Adhesive mounting

You will need a sheet of glass slightly larger than your mount to use as a weight; a soft cloth or rubber roller (4-6 in/10-5 cm) and a wide brush. When choosing the adhesive avoid rubber solutions because they lose their adhesiveness when they dry; spray adhesives (which can be bought in any art shop) are quick and less messy – test the spray on a piece of paper before you begin to gauge its density. Sheets of adhesive are also available but require a perfect eye and steady hand. If you feel confident, they are an easy way to mount a picture. Tape should not be used except as a temporary measure.

First calculate where the picture is to lie on the board and lightly tick the four corners with a pencil or prick them with a pin. Read the manufacturer's instructions on the adhesive and then apply it to the back of your print. Carefully position the print on the front of the mounting board and smooth out any wrinkles with the roller or cloth, working from the centre outwards.

Because the mount will tend to warp as the adhesive dries, the picture must be counter-mounted. Cut a piece of heavy brown craft paper the same size as the mount. Lightly dampen one side of the paper with clean water, apply adhesive to the other side and then secure it to the back of the mounting board. As the paper dries, it will counteract the drying action of the photograph. Place the picture and mount under the sheet of glass until completely dry.

Wet mounting

Wet mounting is used for creased, torn or very old photographs. Immerse the photograph in clean water and place it face down on a sheet of glass. Using a brush or roller, carefully smooth the surface and apply a thin coat of adhesive to the back of the picture and to the mounting board. Put the picture on the board and gently press out any bubbles. Countermount the board (see above). Check the photograph for any wrinkles or bubbles and smooth out. Let the adhesive dry until it is just moist and place the mounted photograph under the sheet of glass and let dry completely.

Block mounting

This is especially effective for large photographs and means that no frame is needed. Self-adhesive commercial blocks are available in standard sizes but tend to be expensive. To make your own you will need a piece of mounting board about ⅜ in (9 mm) smaller than the print on all sides; cellulose adhesive, a brush, lots of newspaper, a soft cloth or

rubber roller, a large piece of card, a sharp craft knife, a cutting mat and piece of fine glasspaper.

Mix enough cellulose adhesive to cover the print and the board (the board will absorb the first few coats, so make a lot). Soak the photograph in clean water for about 20 minutes. Place several layers of newspaper on your work surface and place the mounting board on top. Apply the adhesive to the back of the board in two applications. Remove your print from the water, let any water drip off and place it picture-side down on the work surface and cover the back with adhesive. Then position it carefully on the board, picture-side up. Using the soft cloth or roller, carefully push out any bubbles or wrinkles from the centre outwards. When dry, put the mounted print picture-side down on a piece of clean card (do not use newspaper or paper, which may damage the print). Put some heavy books evenly on top as a weight and let dry thoroughly (this can take up to two days.) When dry, put the board picture-side down on a cutting mat and, using a sharp knife, trim the excess edges of the print to the edges of the mounting board. Smooth the edges of the board (not the print) with glasspaper. Paint the edges of the board or leave neutral.

Matting

A mat can change any photograph into something quite stunning. It will require a certain amount of experimenting to determine what size border around your picture looks best: some photographs are heightened by having a very wide border, others need almost none at all. In all cases, however, it looks best to have the bottom border slightly wider than the other three. As well, there is a vast range of colours of board to choose from, so think these things through before you buy your supplies. Remember that the mat should never overwhelm the picture, but should simply enhance it.

You will need a very sharp craft knife, metal straightedge and steel tape, large or set square, cutting mat and sharp pencil.

First measure the board to make sure that it is square (the right angles at the corners should be exactly 90 degrees) and trim if necessary. The aperture, or opening, for your picture should overlap the print by about $\frac{1}{8}$ in (3 mm) all round. You can mark this on the board either in pencil or with pin-pricks at the corners. If marking with pencil, do so on the back of the board and cut from the back as well so that the marks will not show.

Before you begin cutting, it is a good idea to practise using the knife and straightedge, which can be tricky for the uninitiated, especially on the corners. Position the blade of the knife at either a 90-degree (for a vertical edge) or 45-degree (for a bevelled edge) angle to the straightedge. Draw the blade firmly and slowly from corner to corner. Avoid stopping, as this will produce a ragged edge, and be careful not to gather speed and overshoot the corners. When all four sides have been cut, lift the centre out. Use glasspaper to neaten the edges.

The mat can now be secured to the mount with adhesive. To make a permanent bond, coat both the mount and the mat with adhesive, let dry and then press together. For a less permanent bond, apply adhesive to only one surface. Your picture is now ready for framing.

Frameless Frames

Photographs can be displayed most effectively without frames to detract from them. There are many types of frameless frames available in standard sizes, from 8 × 10 in (18 × 24 cm) to 24 × 32 in (50 × 70 cm). Most are easily obtained from art shops — your only decision is the size you need and the amount you wish to spend. If you prefer, you can easily make your own. You will need mounting board, a mat, glass or acrylic, and clips or brackets. There are, again, a wide variety of clips and brackets available. The least obtrusive are known as Swiss clips. Whichever you choose, make sure they will fit the width of the mount, print, mat and glass.

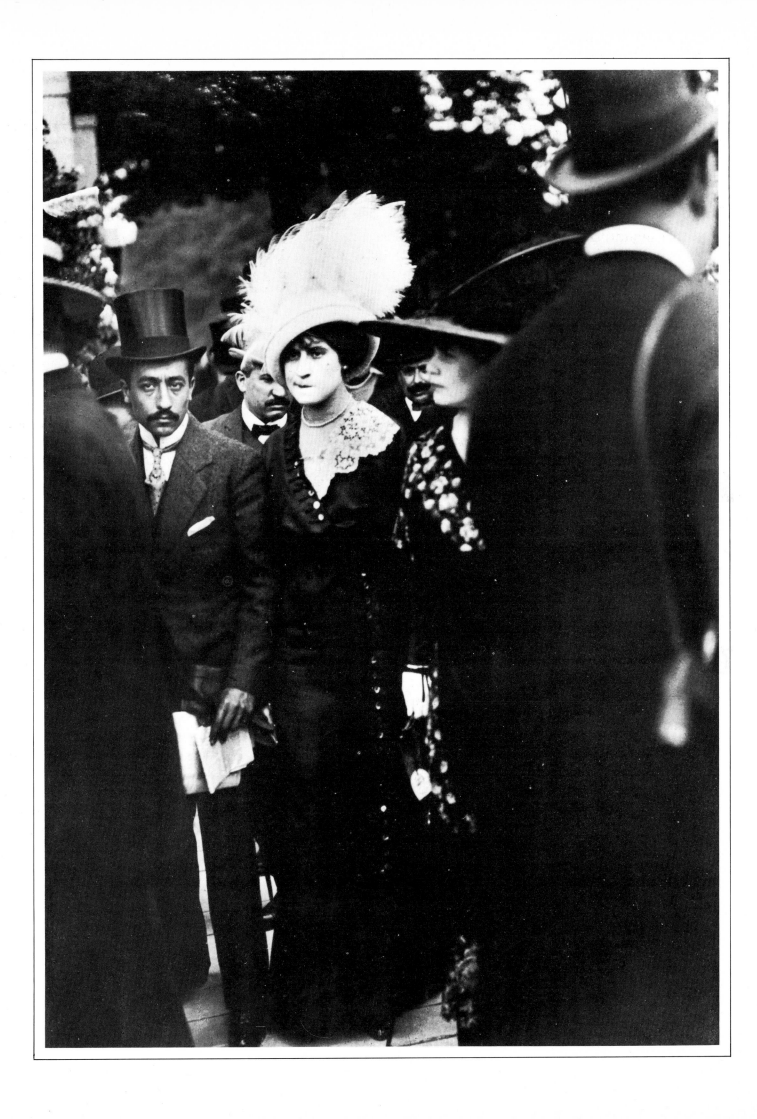

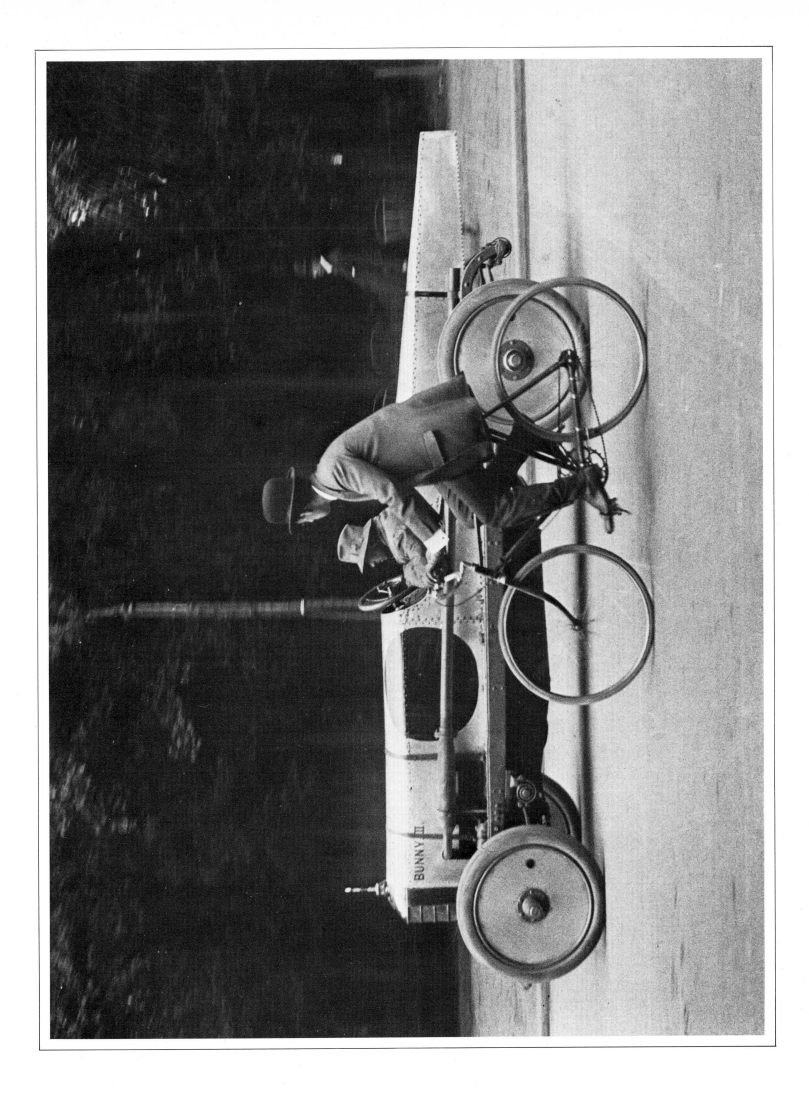

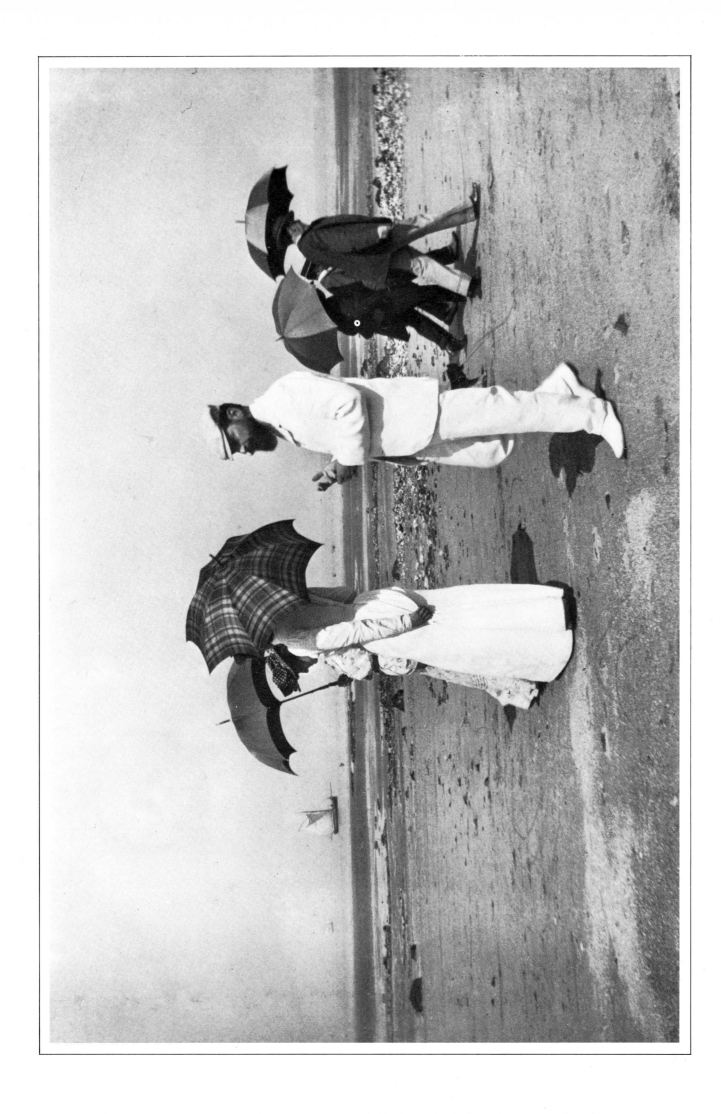

The beach at Villerville, 1906

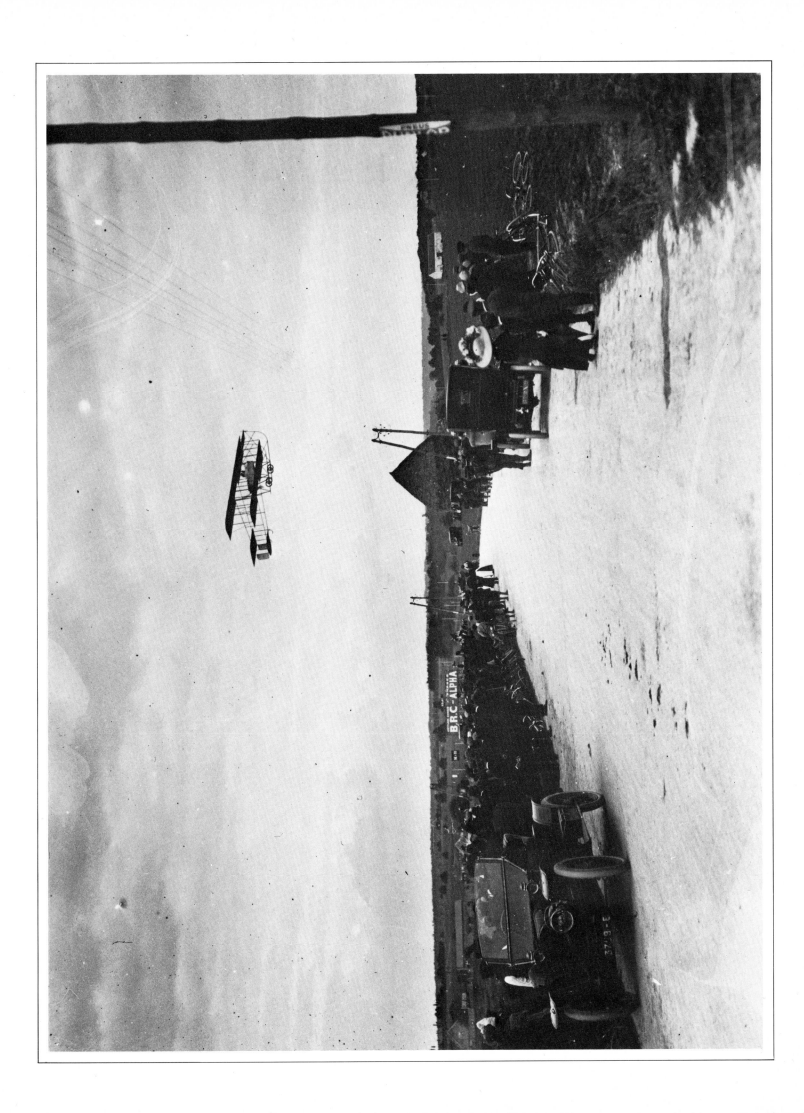

Experiments with aeroplanes near Paris

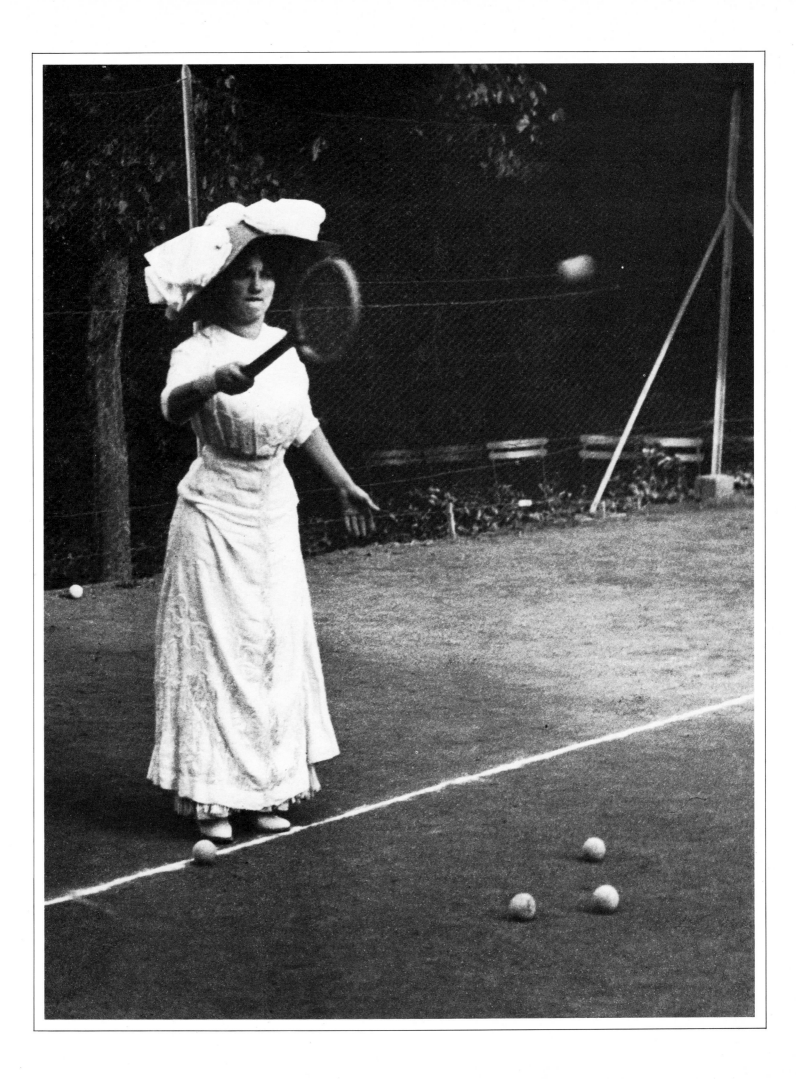

Arlette Dorgère, operetta prima donna, 1910

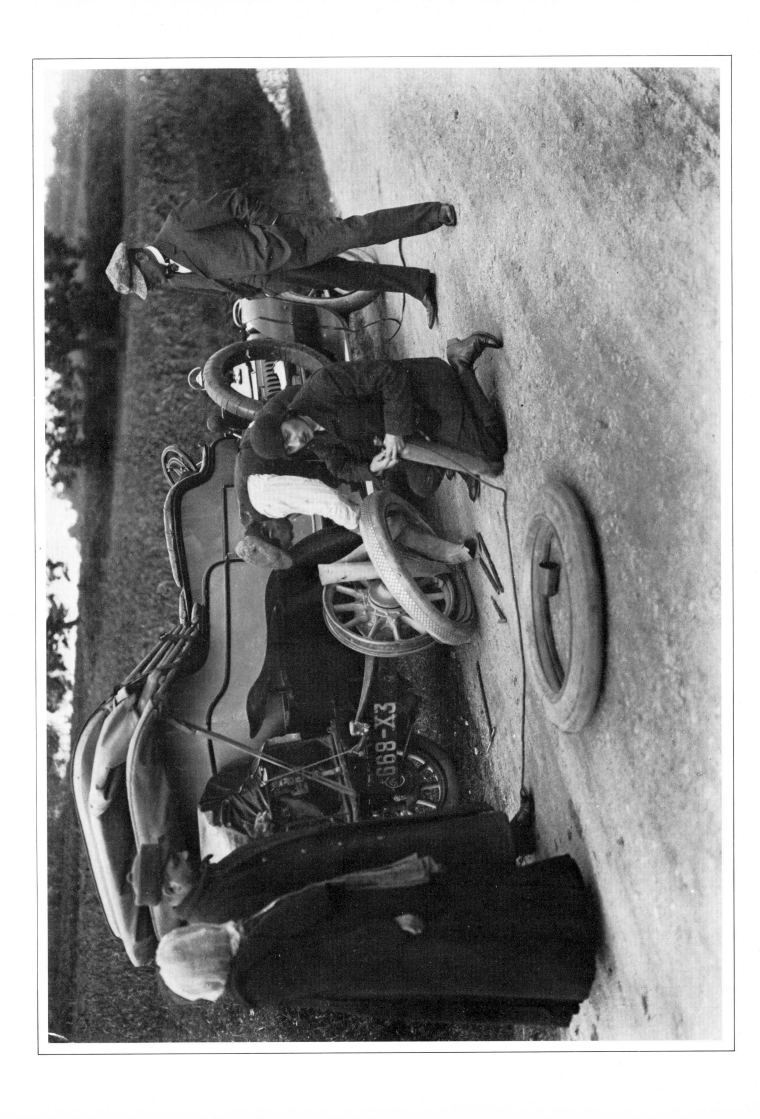

Zissou and Yves change a tyre

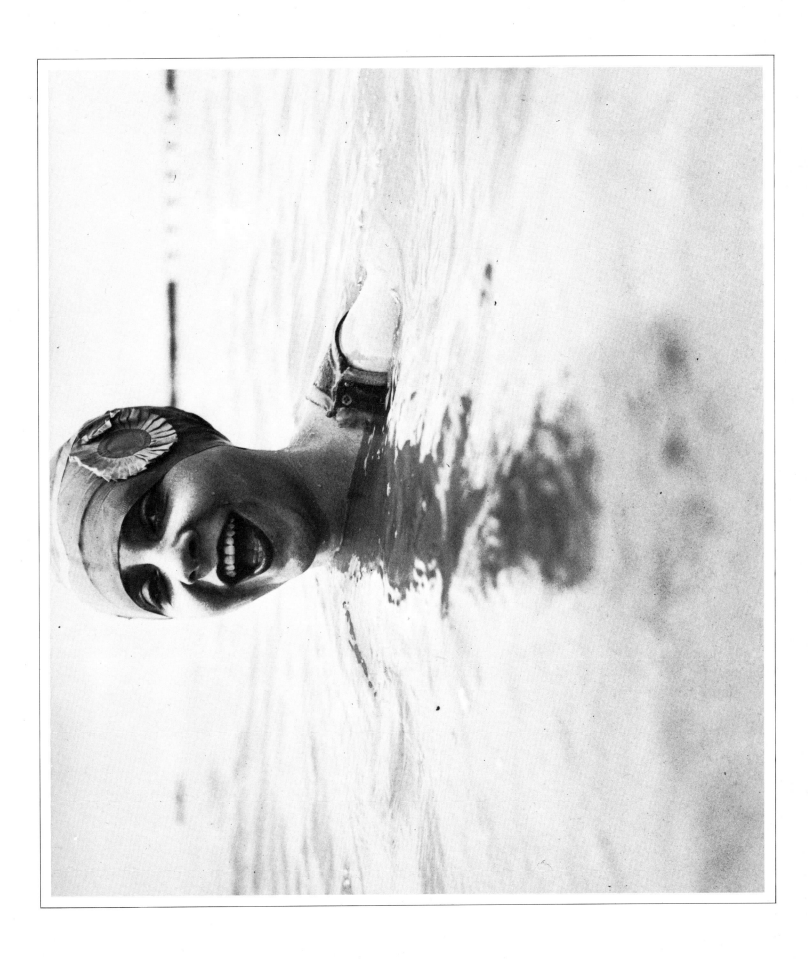

Yvonne Printemps, 1924

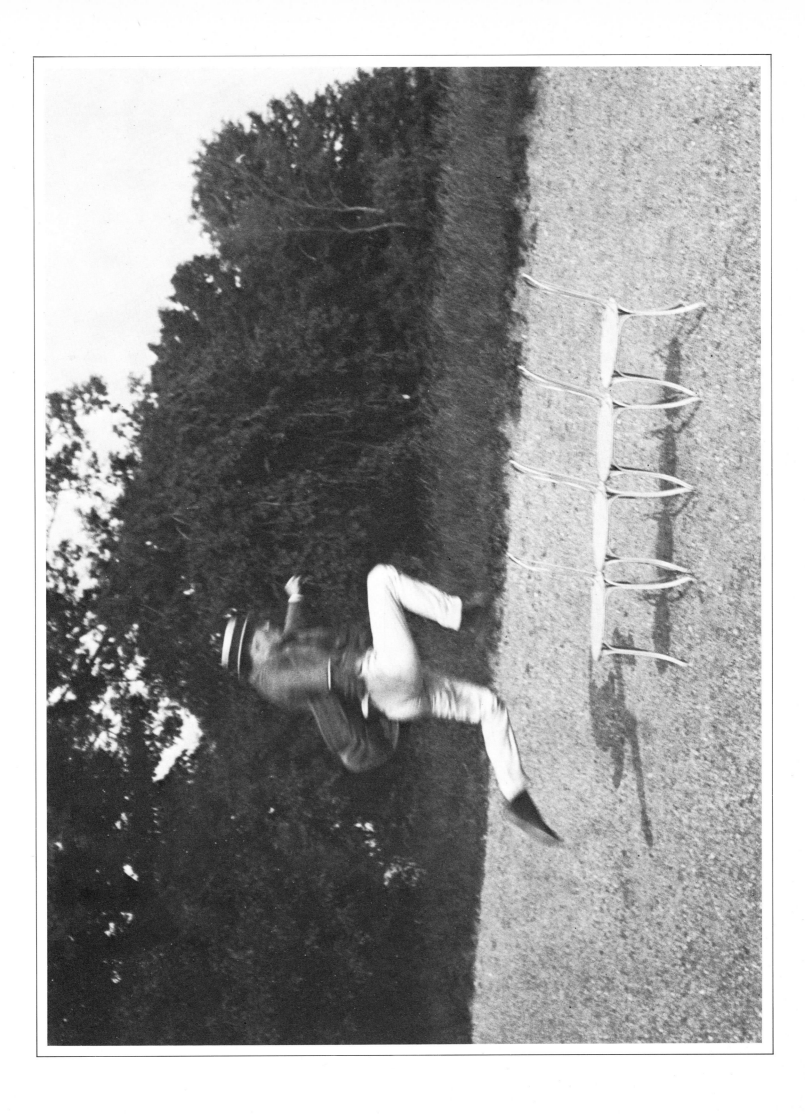

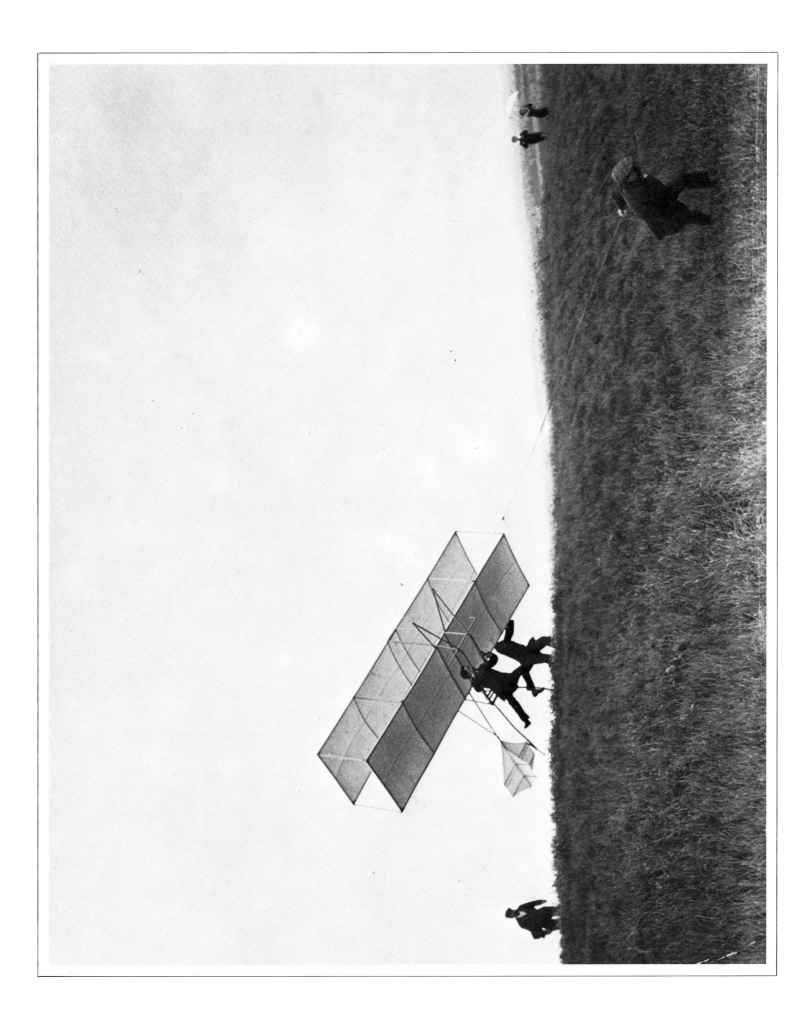

Zissou flies, 1910

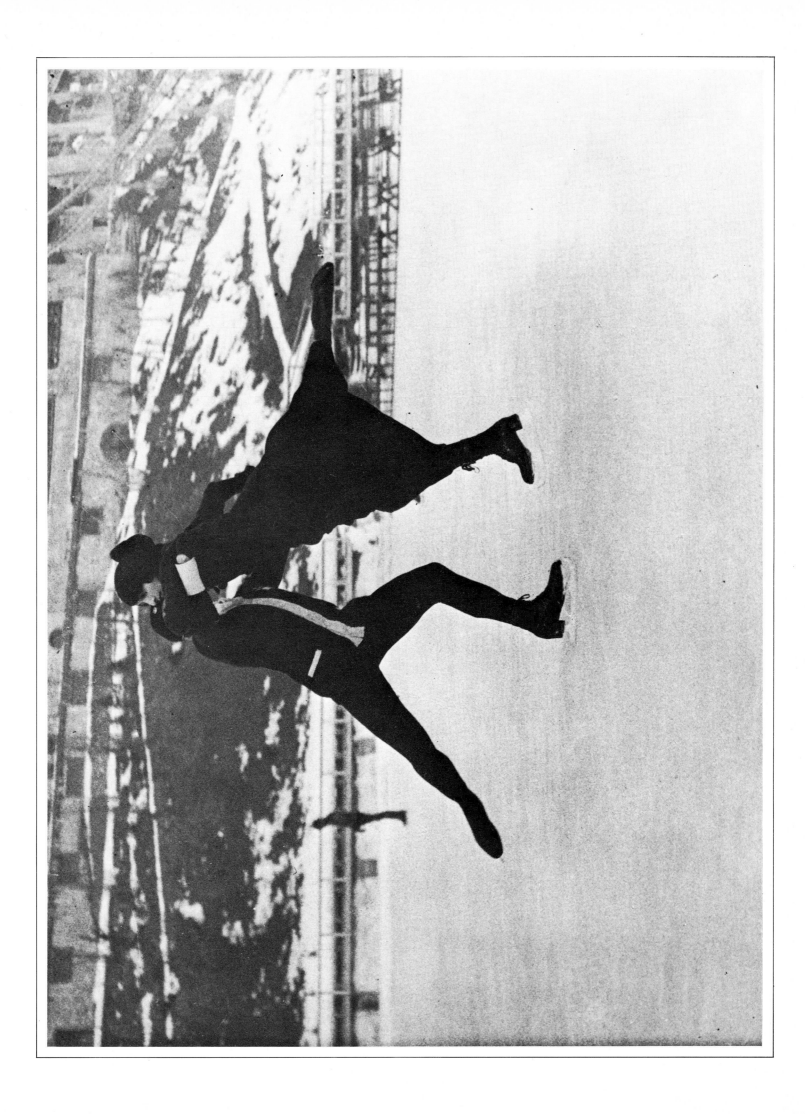

Cousins Simone and Charles Sabouret, St Moritz, 1913

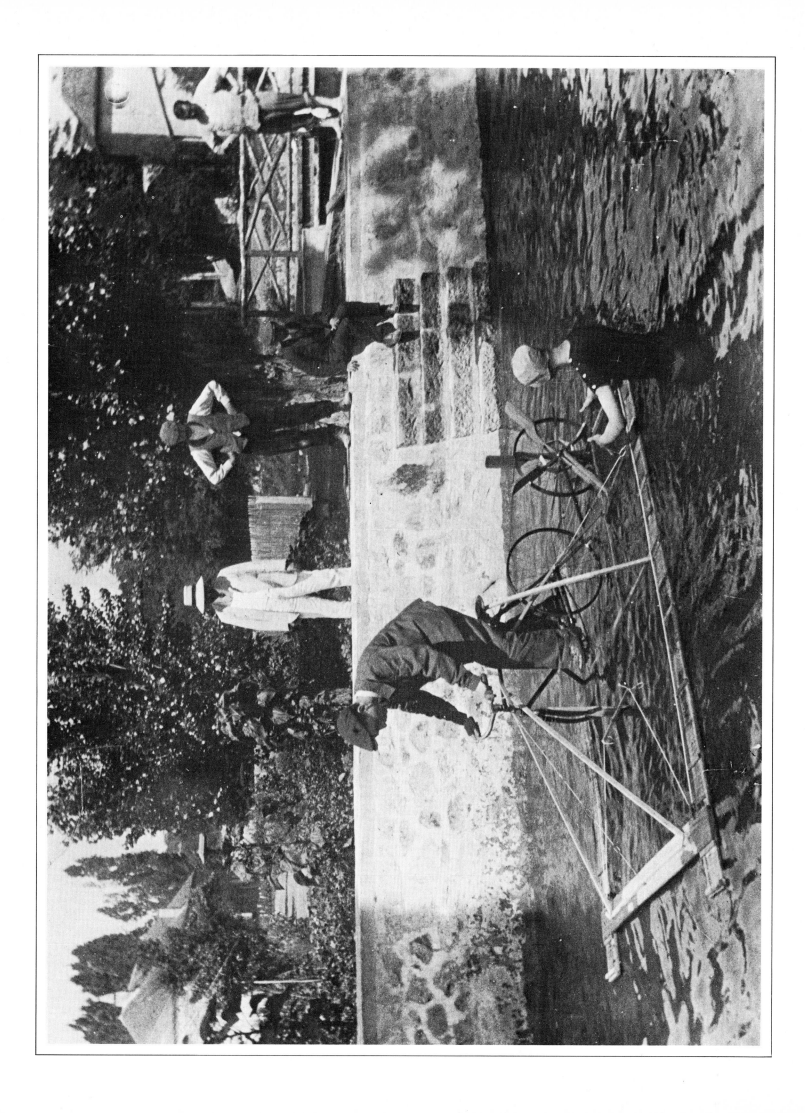

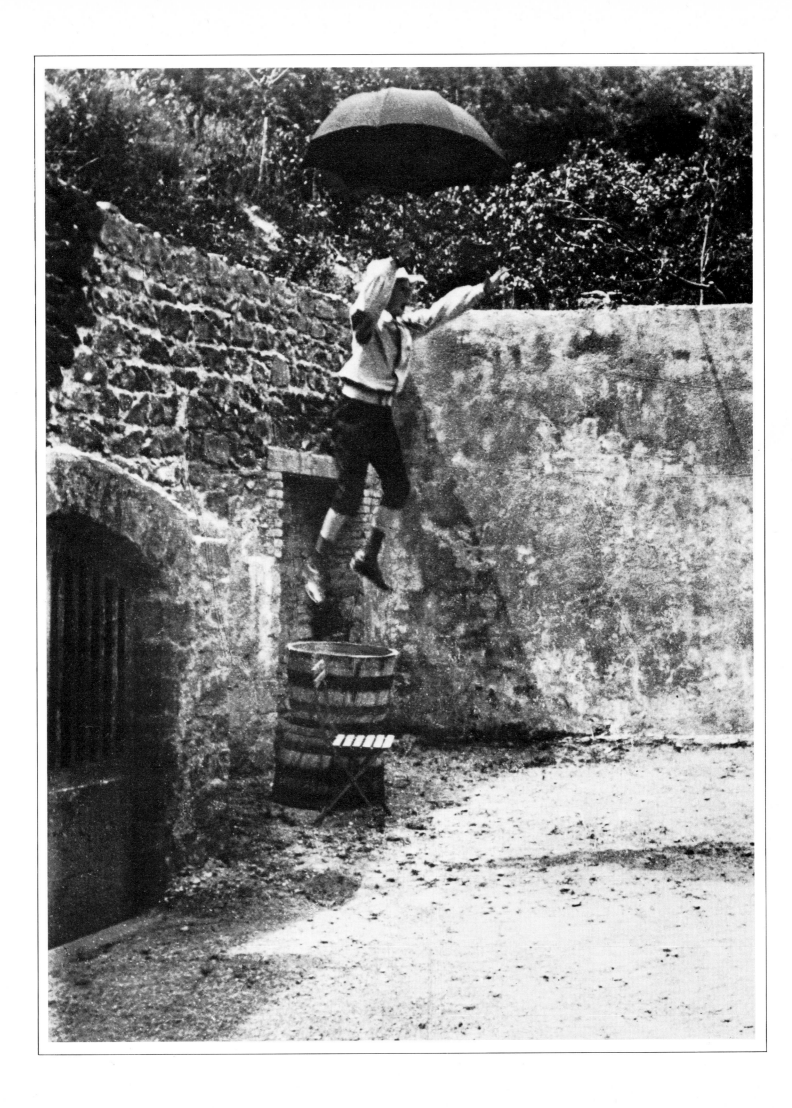

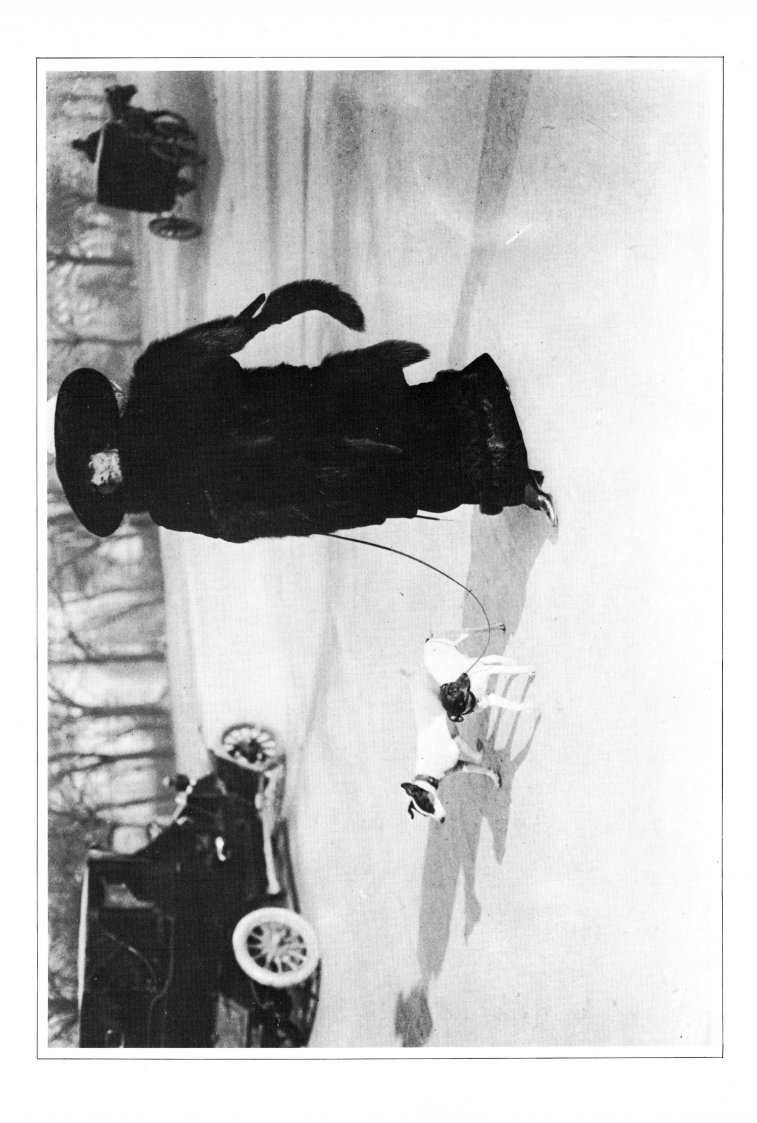

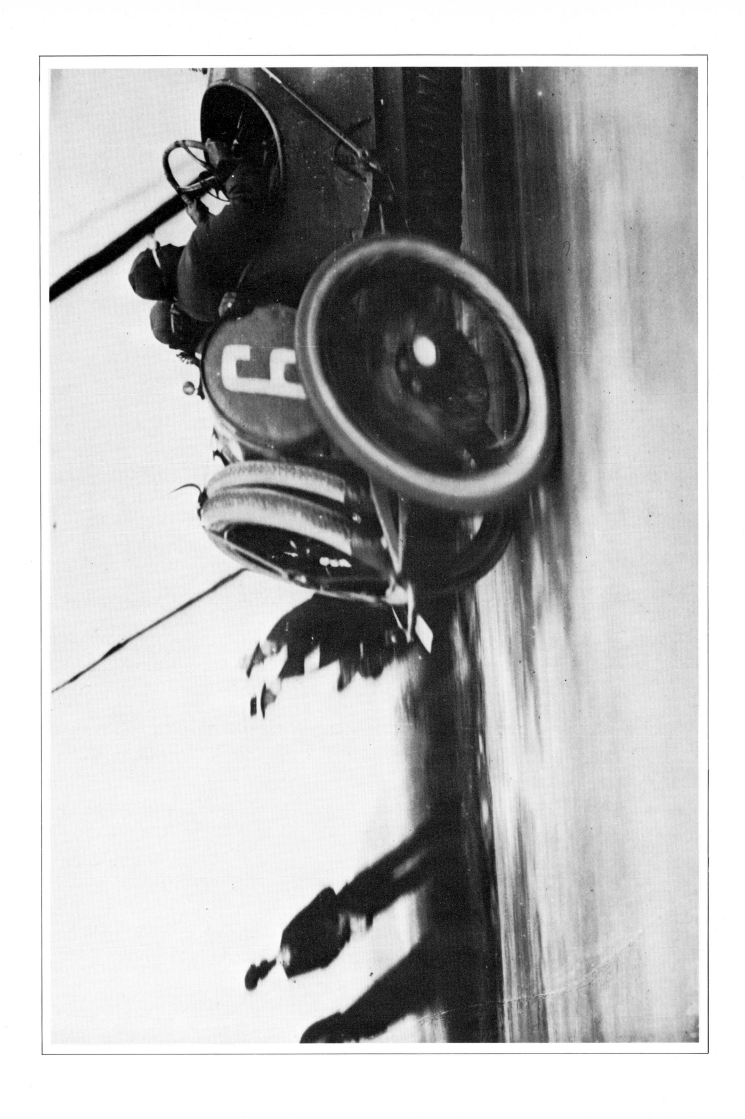

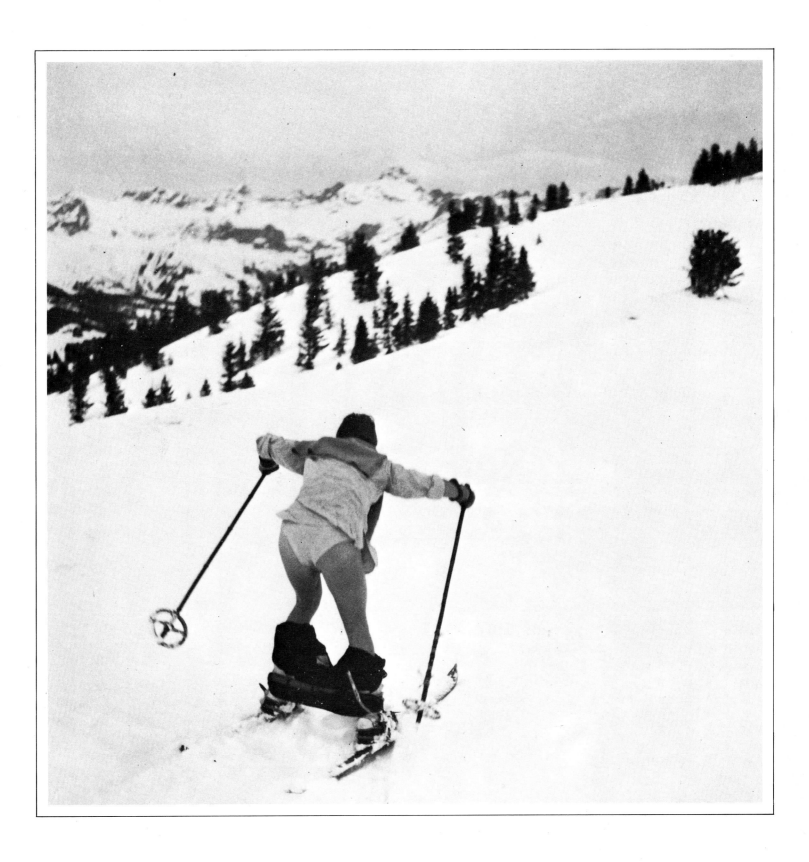

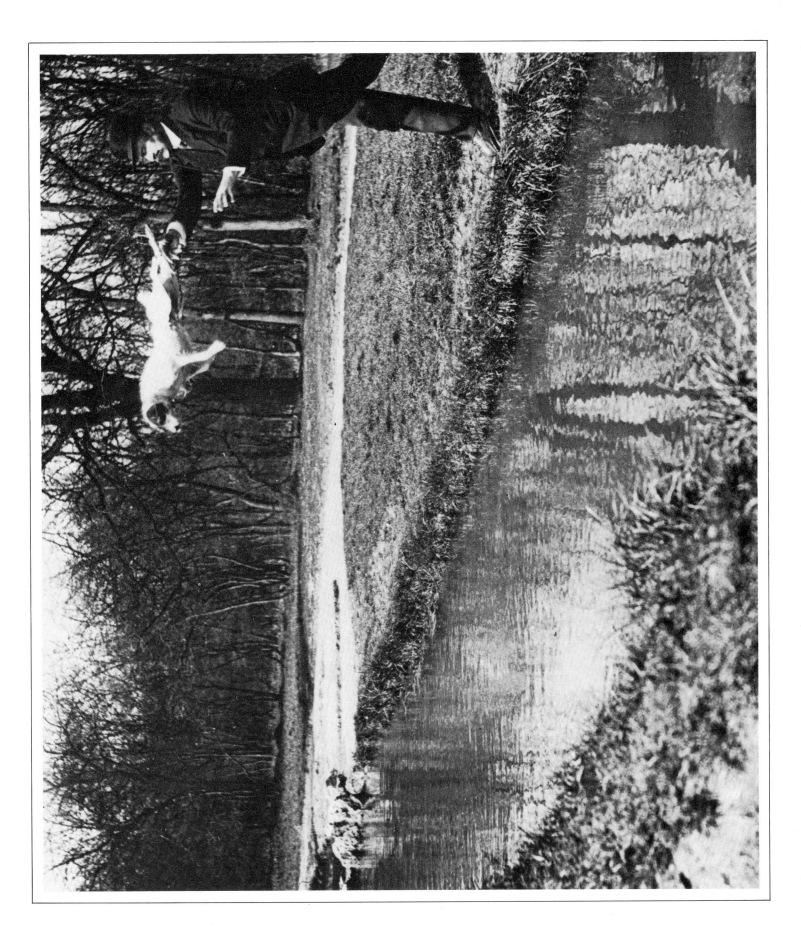

M. Plitt teaching Tupy to jump over a brook, 1912

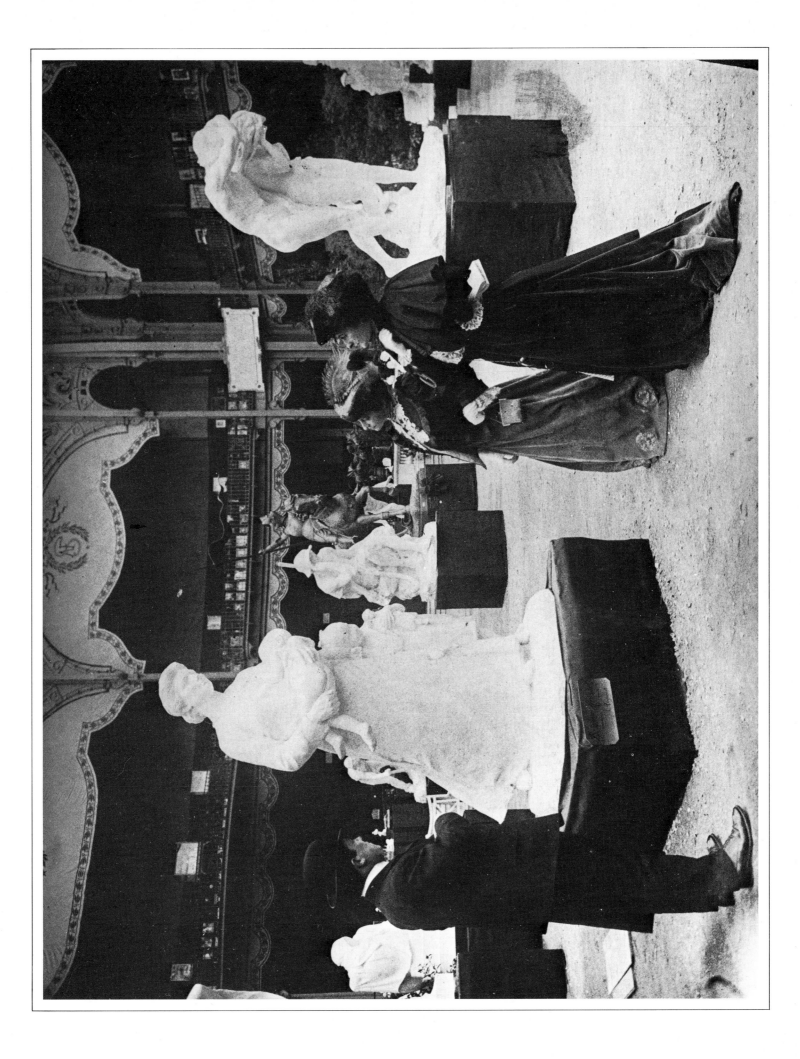

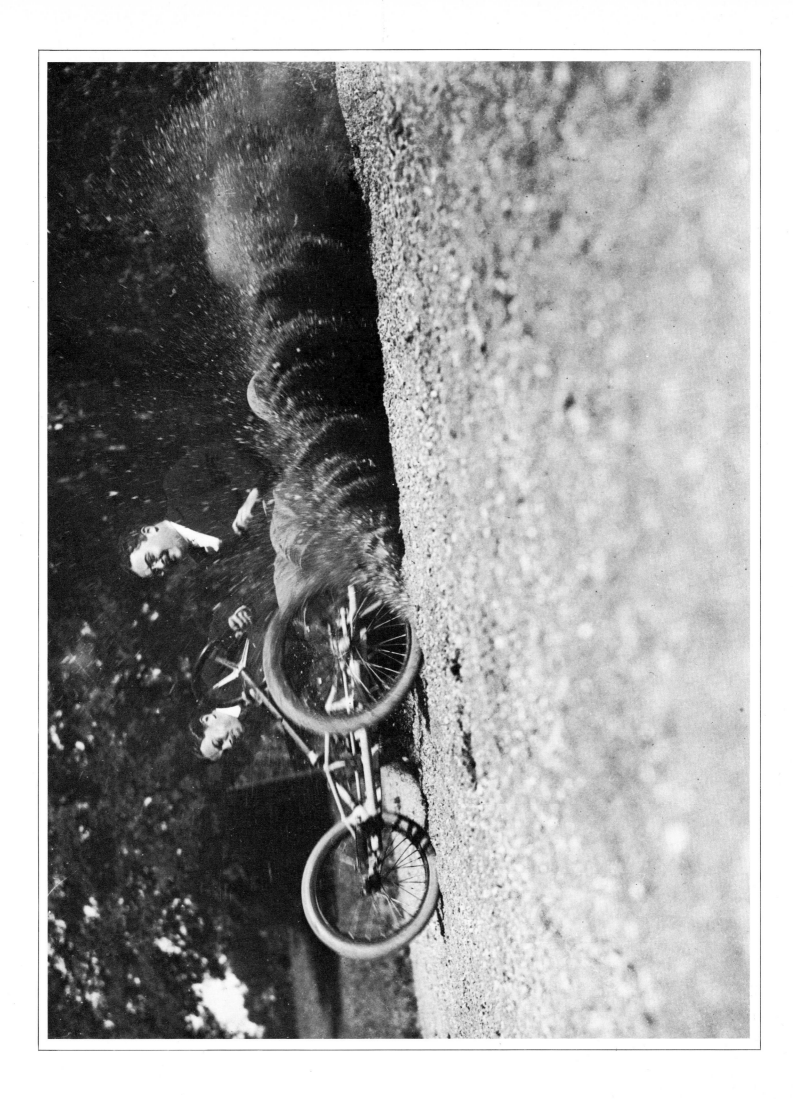

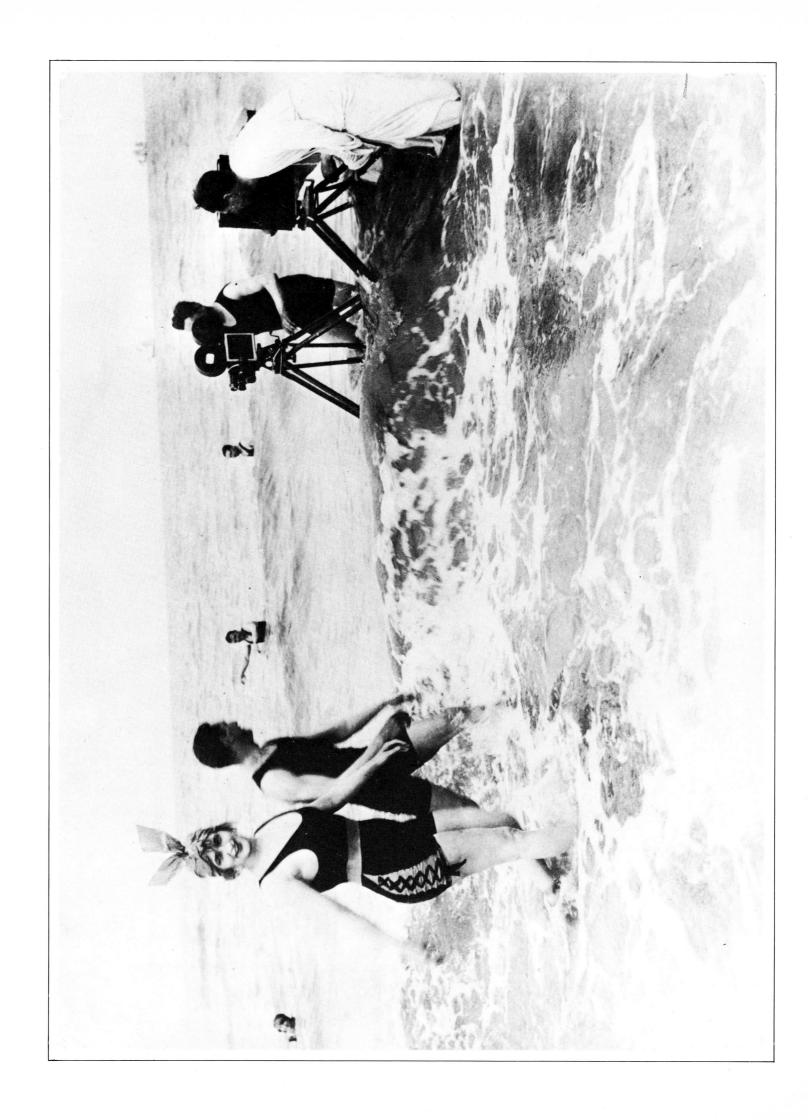

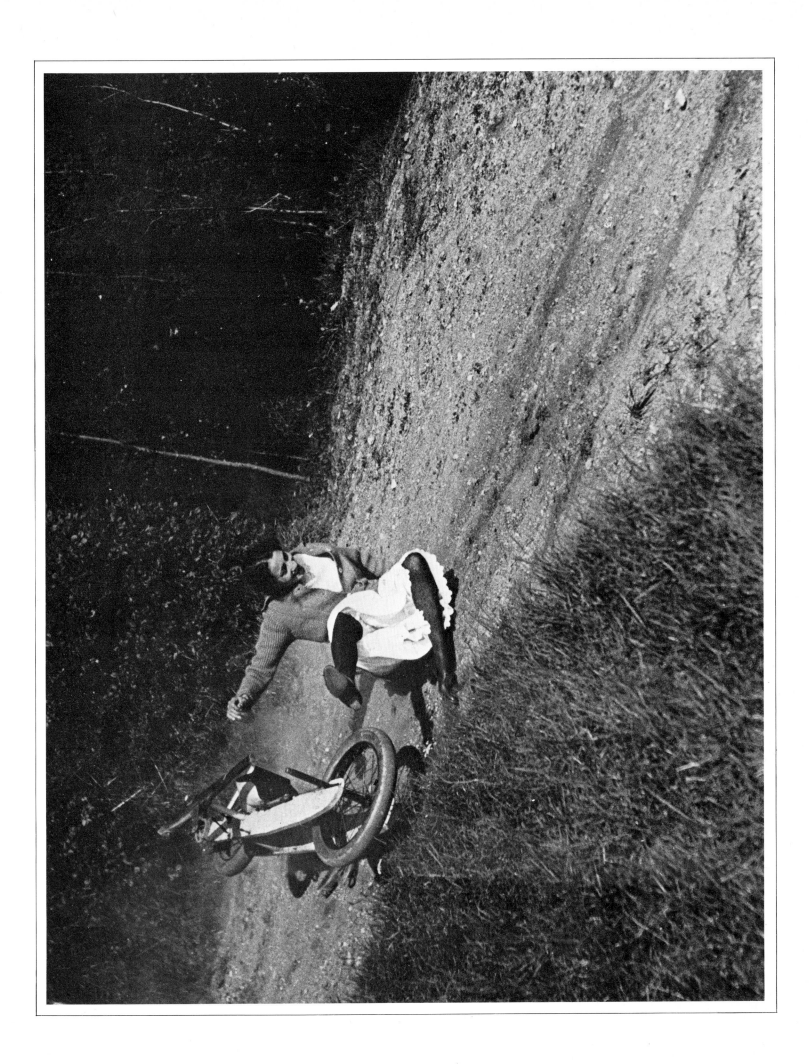

Cousin Simone

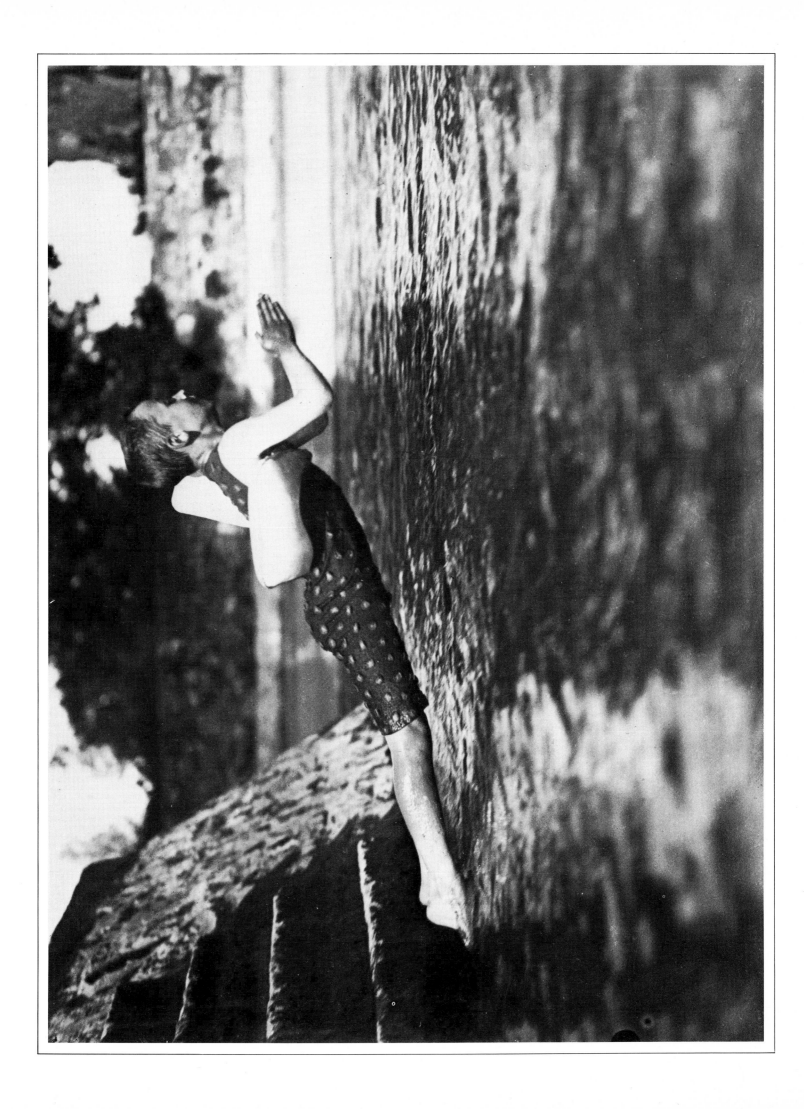

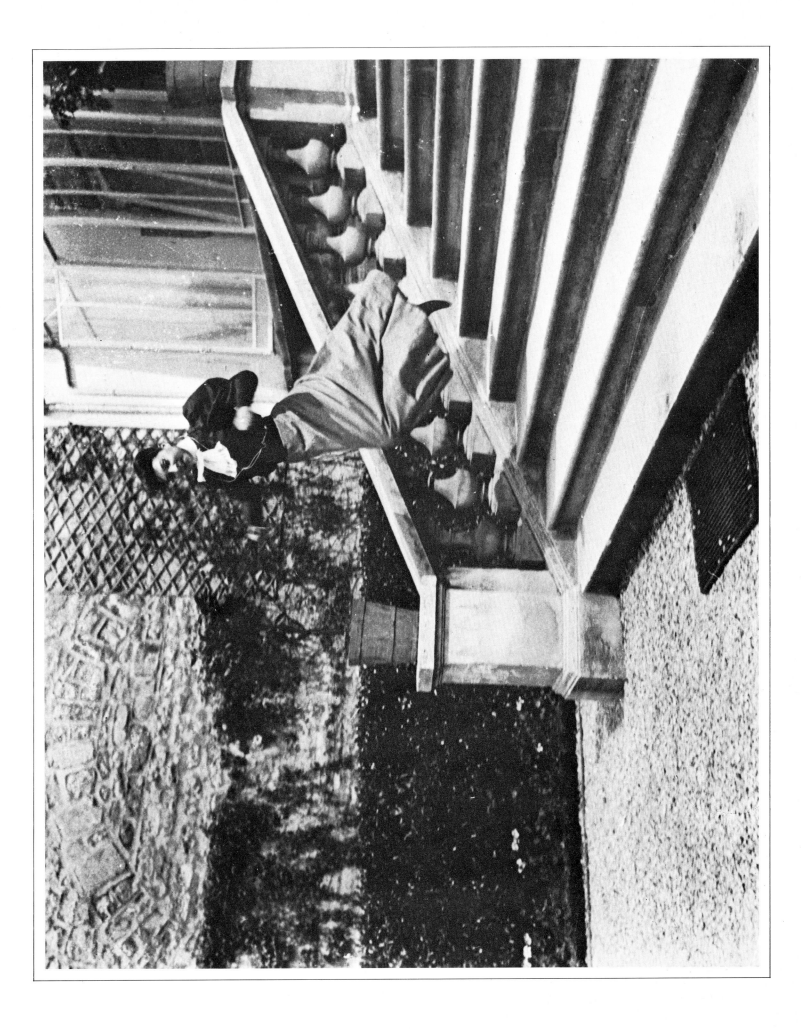

Cousin Bichonnade in flight, 1905

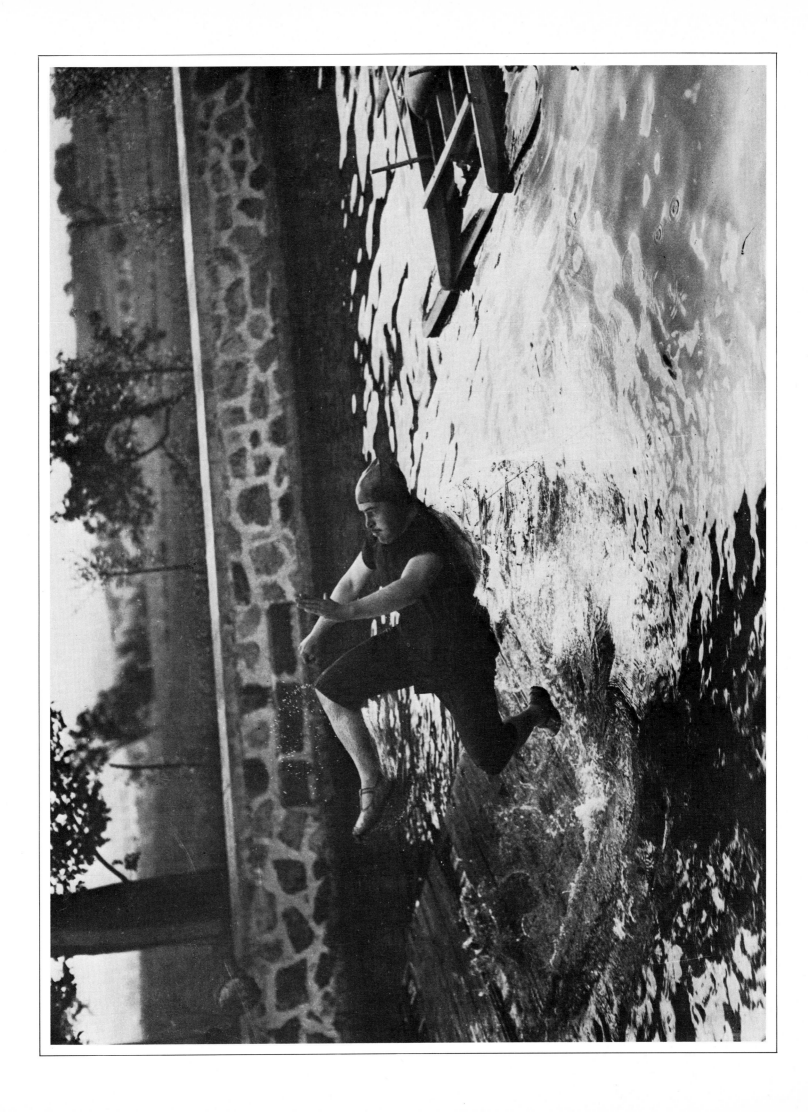

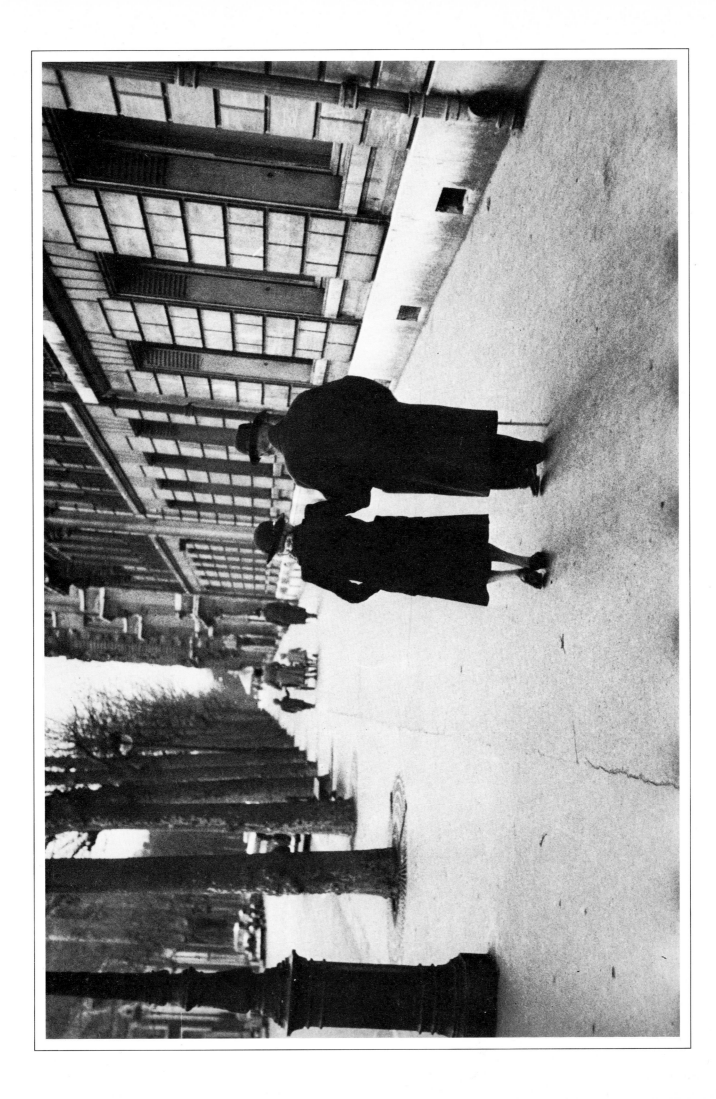

Papa and Mama, 1954

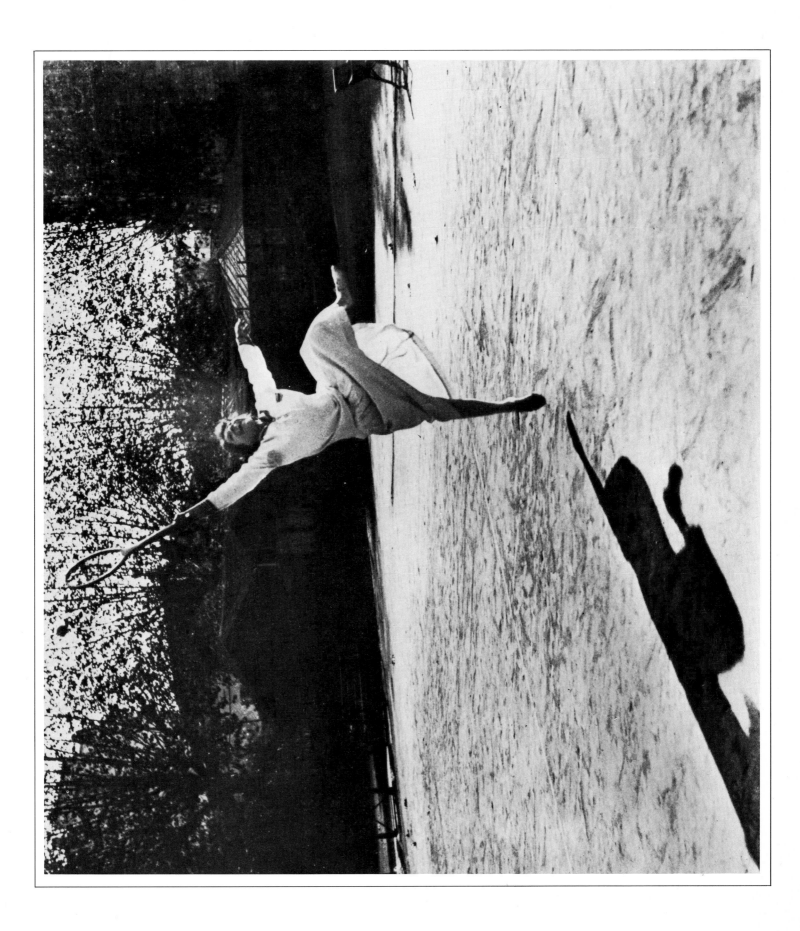

Suzanne Lenglen, 1915